Kevin Bewersdorf

Spirit
Surfing

LINK Editions

Domenico Quaranta, *In Your Computer*, 2011
Valentina Tanni, *Random*, 2011
Miltos Manetas, *In My Computer – Miltos Manetas*, 2011
Gene McHugh, *Post Internet*, 2011
Domenico Quaranta (ed.), *Collect the WWWorld. The Artist as Archivist in the Internet Age*, 2011. Exhibition Catalogue. Texts by Josephine Bosma, Gene McHugh, Joanne McNeil, Domenico Quaranta
Brad Troemel, *Peer Pressure*, 2011
Domenico Quaranta (ed.), *Gazira Babeli*, 2011.
Yves Bernard, Domenico Quaranta (eds.), *Holy Fire. Art of the Digital Age*, 2011

Kevin Bewersdorf
Spirit Surfing

Publisher: LINK Editions, Brescia 2012
www.linkartcenter.eu

This work is licensed under the Creative Commons Attribution-NonCommercial-ShareAlike 3.0 Unported License. To view a copy of this license, visit http://creativecommons.org/licenses/by-nc-sa/3.0/ or send a letter to Creative Commons, 171 Second Street, Suite 300, San Francisco, California, 94105, USA.

Printed and distributed by: Lulu.com
www.lulu.com

ISBN 978-1-291-02040-3

« *The internet has hardly changed our physical lives at all, but it has drastically changed our spiritual lives.* »

_*Kevin Bewersdorf, 2008*

Kevin Bewersdorf is an artist, musician and actor. After playing a central role in the surfing club generation of internet artists, in early 2009 he decided to stop doing art, taking everything he did out of the web, and replacing his online archive with an empty website, purekev.com. He starred in movies, shorts and tv series, including *LOL* (2006) and *Uncle Kent* (2011), both directed by Joe Swamberg.

Contents

Editor's Note 1

ESSAYS 5
> King Lear directed by Jean-Luc Godard 7
> Why I Never Print My Photos (My Run-in with a Skater Mom) 11
> That's Incredible! 17
> Spirit Surfing 21

VISUAL ESSAYS 27
> Jerry Seinfeld as Compared To My Mother 29
> J.S. Bach Apparition (Seen While Pooping) 33
> Buy My Bunny 37
> Yo Picasso! 41
> Victorian Village 49
> Budweiser Clydesdales 53
> The Longest Building I have Ever Seen 57
> Stock Photography Watermarks As The Presence of God 61
> The Four Sacred Logos 71

INTERVIEWS 91
> Interview with Kevin Bewersdorf 93
> One Question Interview: Kevin Bewersdorf 99

Biography 101

Command S Saves 107

Editor's Note

"This site is dedicated to the glory of the INFOspirit. Nothing on this website do I retain personal rights or ownership to, since everything I offer up is a rearranged incarnation of the INFOspirit which binds us all. You may use anything from this site as you see fit, without consulting me or asking me." Kevin Bewersdorf 2008

Kevin Bewersdorf is an actor, musician, philosopher and artist born in Illinois in 1980. As an actor, he played one of the leading characters in *LOL* (2006), produced and directed by Joe Swanberg. He also contributed to the script and wrote the soundtrack of this and other movies.

As an artist, Bewersdorf was very active on the net between 2007 and 2009, when he stopped any activity and attempted to cancel all traces of his presence online. First, he emptied his personal archive maximumsorrow.com, replacing it with a new homepage, purekev.com: a site / performance that featured a white flame against a blue background ("my light on the web"), destined to shrink a little smaller every day. While I write, the site is just a blank web page. Finally, he deleted his other domains (like that of the GEARt.e.k corporation, a company he was founder and CEO of) and his accounts on online platforms such as YouTube.

Despite this, Bewersdorf has not managed to wipe his entire "artistic identity" off the net. There remain his posts on Spirit Surfers, the blog he co-founded and worked on up to 2009, listed under the username "INFOpruner". There remains the wonderful visual essay published on the blog *Art Fag City* in 2008, an analysis of images of prayer in commercial image banks, comparing the glossy, fake religiosity of the images with the authentically sacrosanct nature of their watermarks – the logo superimposed to prevent free use. There remain random interviews, articles and comments, a few animated gifs, the photos of a few physical works, his music, his digital photos spread on different blog and websites.

Digging a little deeper, you can find some back-ups of the contents of his website between 2007 and 2009, kindly saved by the formidable initiative Internet Archive (www.archive.org), and accessible through its "wayback machine". Most of the texts featured in this book are actually coming from there. Unfortunately, the Internet Archive didn't save images and other files embedded in the html of the web pages. That's why, in this book, missing images and files featured in the "visual essays" are replaced with a missing image icon.

All together, this is not much to get a complete picture of the artist, but enough to turn any web surfer who comes across these fragments and perceives their transient nature into a keen collector.

In "The History of My Life (formerly "BIO")", a short biographical statement featured at the end of this book, Bewersdorf wrote:

> "I would drop [my laptop] off a cliff without hesitation (a computer is just one of many portals to the INFOspirit). The seeds of my data are already safely spread across the web, and this data is what concerns me."

In the light of this statement, rather than being a nihilist strategy, his next move – retiring and deleting everything he put online – actually seems to be a confident leap into the void, an act of complete faith in the passion for collecting of those who surf the web: what really counts will be saved thanks to them. Kevin Bewersdorf's work won't be saved for the future by museums and rich collectors, but by simple internet users, like you and me.

Not being a man of faith, I'm not sure that it will happen. What I'm sure of is that this move into ephemerality turned me at least into a collector, and a stalker. Though mainly digital, and thus perfectly reproducible, Kevin's work is now officially subject to the condition of scarcity, the premise to any act of collecting. In absence of the original, low-res versions of his photos and videos, poor documentation pictures, mp3s, fragmentary texts suddenly become rare and precious: something that we have to save if we want to save a small, but relevant, portion of contemporary art that would be otherwise lost or fragmentary.

This book is a first step in this direction. The texts featured here have been collected and edited by me, without the consent of the author, but according to the philosophy declared in the opening quote. Though relatively recent, and in digital form, they are already fragmentary and need restoration, like the ones featured on a badly preserved manuscript from the Middle Ages.

The book itself is part of a wider project, that can be publicly accessed at the URL shareyoursorrow.linkartcenter.eu. *Share Your Sorrow* is a public archive of Kevin Bewersdorf's work that, like this book, collects what's still publicly available though difficult to retrieve, but also invites people – friends and pals of the artist, amateurs who saved his works and texts when

they were still available online – to submit and share what they saved. Thus, *Share Your Sorrow* is an experiment in social preservation of an art practice that, being digital and publicly available online, allows and, in a way, pretends this kind of approach. An approach in which everybody can have a role.

Because, in the end, WE ARE THE INTERNET.

<div style="text-align: right">Domenico Quaranta, August 2012</div>

ESSAYS

King Lear directed by Jean-Luc Godard

I wouldn't be writing a review of this film (its not new) if it were not for two important reasons. Firstly, I saw its first public showing ever – previously only press at Cannes in 1987 had seen it. And secondly because I happened to meet the lead actor of the film, Peter Sellars, at the Romaeuropa festival here in Rome. An amazing night to be a Film Brat.

I entered the crowded euro-trashy theater with the appropriate caution for viewing a Godard film, took my seat, and noticed a mysterious little man milling around like a creepy David Lynch (if that's not redundant). The director of the festival began her speech in proper Italian and eventually introduced this man to be Peter Sellars. Sellars stood and said a few words about the film and his involvement with Godard. His honest unwavering English broken only by the Italian translation gave me a new appreciation for Godard as well as insights available only by talking to someone who knew him, someone who was there. Once you have this kind of insight, once you see a man in the room with you and then the next moment on screen, the experience of cinema becomes even more surreal.

According to Sellars (who is hilarious by the way) Godard signed the contract for this film in 1986 on a napkin, and when that ran out of space, the corner of a table cloth. As always he had worked out all the finances but had no idea what the film was going to be about. Cannon Films had the sole stipulation that Godard finish it in time for Cannes. Norman Mailer had an idea to do Shakespeare's King Lear (strangely at the same moment Akira Kurosawa was writing a deal to make Ran, his own adaptation of King Lear). Mailer was to play King Lear but walked off the set during the first week (the shot of this happening is left in the film). Godard decided to hire Sellars to replace him since he had performed King Lear many times. Ironically enough Sellars plays a character named "William Shakespeare Jr. the 5th" who has nothing to do with the original play. In fact, Godard's King Lear has almost no similarity to Shakespeare's. I would have thought that there was something I was missing if Sellars had not told me that Godard had in fact never read King Lear. Godard had read the first three pages and the last three pages only, and, I quote Sellars as directly as I can, "this entire film is Godard trying to get to page four of King Lear."

Isn't that just some kind of pretentious apathy, that Godard hadn't even read the play? As enraging as his artsy French schmaltz can be, I will assert here that it is not. The first few scenes are cut in odd repetition, some multiple takes of the same scene, then repeated voice-overs of Godard's garbled nearly inaudible narration. These are some of the only actual lines from the play because this opening represents Godard reading and re-reading those first three pages, trying to understand. As the film moves

forward it is distracted from Shakespeare into insane noises and senseless Monty-Python style antics. Godard is saying that we can re-read and re-read these pages but we cannot understand them. While everyone else is trying to grasp Act five, Godard is still on page three. So reflects the narrative on screen. The middle of the film goes into a bit about the perception of cinema, throws around more wild editing and lots more schizophrenic sounds of seagulls and pigs eating and Godard spouting muffled possibly Shakespearean words (the soundtrack is by far the most interesting part of this piece). This free use of the text so infuriated the people at Cannes that the film was never released – understandably so. It is an assault on the senses, is almost not watchable at times and in fact defies that you could possibly "enjoy" it.

Had I not spoken with Peter I would have made a more suspended judgment of taste on this film. It was too much to digest. But he assured me, "Godard has made a total piece of shit." And that he wanted it to be that way, that he wanted to turn the camera away from the beautiful vista and shoot something that could not be understood, something irritating but with moments of intense and undeniable beauty. And that's what he made. Godard shot the film in five days and sent the other actors (Woody Allen and Molly Ringwald among them) back home. He completed the film with only himself and Sellars. Woody Allen plays the editor of the film and is named "Mr. Alien." He has two lines, then Godard comes into the editing room with plugs and wires and strips of film in his hair and falls onto a pile of film. Why is that good? I can't explain it just like Godard can't explain Shakespeare. But some of the imagery is just so beautiful – it's more a painting than it is a film. Christ, you want to hate this film so bad, call it boring and pompous, but you just can't. Not if you have eyes and a love for cinema. It's too beautiful.

First published on Filmbrats.com, undated. Online at www.filmbrats.com/reviews/k/kingbykevin.html.
King Lear was presented at Romaeuropa Festival in 2002.

Why I Never Print My Photos (My Run-in with a Skater Mom)

The mother of an eight-year-old skate boarder recently forced me to delete artwork from my digital camera. The incident occurred at a newly constructed skate park in my hometown of Naperville Illinois where I had peddled on an ailing mountain bike with the intention of photographing the privileged ineptitude of young skaters. Paralleled above by rows of electrical wires and below by padded fencing and lawnmower stripes, the simple gray pipes and ramps of the skate park were framed by parking lot lights and balanced by the bland wisps of skater fashion, all frozen in a barren geometry. I noticed that a Gatorade vending machine had been toppled over near the edge of the pavilion. The machine appeared to have become so dehydrated, so weary of being extreme, that it had fainted face down onto the concrete. I dismounted my bike to photograph the Gatorade machine and the skate ramp looming beyond it, when a lone skater suddenly stumbled into the air above the logo, poising himself at the tip of the pyramid with all the shitty majesty America can muster. The picture was perfectly symmetrical and rendered in a flawless global light, and it said everything I ever wanted to say about Gatorade. I was forced to delete it because the child skater in that photo has more rights than me or any living artist.

After sufficiently contemplating the Gatorade machine and sweeping the skate park for subjects, I noticed that the only other person in the vicinity over the age of fifteen was a middle-aged woman seated on a lawn chair under the pavilion. She was periodically taking note of my position between glances at her book, watching me lean and squat as I searched for acceptable compositions. Eventually the woman approached me and asked why I was taking pictures of the skate park. I told her that I was an artist, and that I take pictures of America. She told me that I was not allowed to take pictures of kids in public and asked me to delete any photos I had taken of her children.

I told the woman, "I understand your concern, but technically, by law, I am allowed to take photos in public." Confused, she argued that schools needed parental permission to take photos of children. She demanded to see my "photographer's credentials." I explained to her that while schools were liable government institutions, I was an artist and private citizen photographing for my own leisure in a public place. "As a human being though, think about it, you shouldn't do that," she replied, "a girl was abducted in my neighborhood. There are a lot of perverts out there and I don't know what you're going to do with these pictures. You could be putting them on the internet for all I know!" I didn't want to upset her further so I apologized for the misunderstanding and said that I would

delete the photos of her kids. "I understand why you're upset," I said nervously, "but it saddens me to delete these pictures because I really like some of them. I do not intend to exploit your children and legally I do have a right to these images." She shrieked, "How dare you claim to have rights over a child! This is exploitation of kids, and that makes you a bad human being."

She said she was going to call the police. I encouraged her to call the police, so they could confirm that I was doing nothing illegal. I have encountered the police dozens of times while taking photos in America. Once, while photographing houses at night, a squad car with blazing searchlights swarmed me for questioning as a pair of officers physically restrained a bath-robed homeowner who was screaming at me from a nearby yard, "there he is, that's him! He was taking photos of my boat!" I have been tailed by white security vans around the perimeters of office parks, had my ID examined at length on manicured lawns, been shouted at from moving vehicles, had my license plate number written down by dads and various men wearing sunglasses, and waited patiently in parking lots for my background to be checked via police radio. I told the woman about these encounters and the seemingly new paranoia of photography that so disappointed and frustrated me, but she only took this as an admission of guilt. Implicating her as paranoid made her even more paranoid, and she demanded that I follow her to a nearby minivan to write down my contact information. I did this, out of courtesy to her, to prove that I had nothing to hide. After giving her my name and address I asked, "and what is your name by the way?" She screamed at me, "NO I AM NOT GIVING YOU MY NAME YOU HAVE NO RIGHT TO KNOW MY NAME." Her round haircut was bobbing all over the place.

By this time all the kids at the skate park had stopped grinding and were lazily leaning along the fence, watching us as if at a bullfight. One of the skaters shouted, "Maybe you're Michael Jackson's brother you pervert!" I don't know how many times in my life I've had to convince people that I am not a pervert, but I am really not a pervert. Unable to hold out any longer against the threats and accusations, I stood in the shade with this woman as we reviewed and erased almost every image on my memory card. Any photo depicting a child had to go. I asked her if I could keep a few as evidence for the police, but she yelled, "NOT OF MY KIDS YOU ARE NOT, YOU HAVE NO RIGHT TO DO THAT." She kept telling me about "rights."

THE ORDER OF RIGHTS IN AMERICA

1) White children under the age of 12

2) Babies (any race)

3) Moms and Dads

4) People serving our country

5) The Elderly and teenagers

6) Foreigners and illegal aliens

7) Murderers and rapists

8) Child Molesters

9) Artists

After safely sealing her skate angels inside the Tupperware vehicle, the woman assured me that policemen would be showing up at my address to arrest me. I told her she would have to go to the Supreme Court if she wanted me arrested. I peddled home cautiously, expecting to see a shotgun aimed at me as I rounded my driveway, or maybe the woman's stocky ex-marine husband stomping around my yard with a baseball bat yelling, "where's that pervert who was takin' pictures of my kids?" Perhaps I should have been wearing a phony "official photographer" ID badge around my neck at the skatepark. Even though a person with both permission and credentials (such as a counselor or a priest) is actually more capable of exploiting children than I am, my only credentials are that of "artist." Since I can't describe what an artist is or why an artist does what he or she does, I could never justify my photographs or attain permission to take them.

What if I had set up an easel at the skate park that day and begun painting the children in photo realistic likeness? This woman would have certainly showered my painting with compliments. Maybe she would have offered to buy it. Or what if I had carefully set up a large format camera on a tripod at the skate park? The woman probably would have been fascinated by my mastery of such a complex instrument (complete with one of those little black sheets that real photographers hide under) and considered its traditional luxury to be the proof of my artist's credentials. Maybe she would have bought the photo and hung it with her other furniture. But if I wander up to that same skate park with a tiny consumer-

grade digital camera, intending to post the photos online (also an art practice), I am considered a pervert. A digital photo is not an artwork in the minds of mothers. A digital photo is a dangerously instantaneous and innately dispersible document that requires little skill to manually execute. A digital photo is difficult to regulate and understand as a commodity. In its purest form, a digital photo is not even visible. That terrifies mothers. It is the threat of invincibility that is so terrifying. A non-physical thing has so much more power than a physical thing now – enough power to enrage a mother to the point of spitting all over her lipstick – and for this reason I will always take digital photos and never object photos.

This woman wouldn't tell me her name (although I told her mine) but she looked like a Donna. I want to say something to her now, if she is reading this: Donna, you are being photographed from every bank ATM, from every grocery store, from every distant parking lot and every corridor, from millions of stray camera phones and from satellites in space. My surveillance of your children is a fart in a hurricane of surveillance. And a fart in a hurricane loses all its rudeness. Donna, I will continue to take photos of American strangers in public places, not because it is my legal right but because it is my artistic desire. I will continue to post these photos on the web where you will be unable to own or regulate them. I will never question the misuse or morality of my pictures, because misuse and morality are subjective issues outside of my control. You can't stop me Donna, no matter how many moms call the police on me and no matter how many cool skater punks call me a pervert.

Kevin Bewersdorf 2005.

That's Incredible!

My earliest childhood memory consists of a mustard colored wall and a deformed male head with two mouths. Presumably God or Nature had sliced the spare mouth into a plateau of flesh just to the left of this man's other more normally placed mouth. His second mouth had rows of misplaced teeth and I could see weird stalactites of saliva stretching and breaking as he opened and closed it casually. He smoked a cigarette out of both mouths simultaneously and blew some smoke in my direction with a squint. The mustard color of the wall is equally as vivid in my mind as the deformity, and it coordinated well with the exotic complexion of the man's skin. I should stress how certain I am that this actually happened to me, probably at a State Fair or grocery store in the very early 1980s, and although this event has always been a profound mystery to me personally I am aware that my childhood memories are largely ineffective when retold and not that incredible to anyone else.

Twenty-some years later I was at a hotel party in Boston, drinking Crown Royal out of paper cups with five strangers I had met that day: a DJ, the DJ's young wife, a producer from Los Angeles who wore a scarf and distant expression, a guy who was definitely gay but not a rapper, and a gay rapper named "Juba" who had a chin ring and thirty-six inch dreadlocks and was squatting on a chair near the bathroom. The hotel room was decorated in a variety of mustard and goldenrod tones. Most of my new drinking buddies were promoting a documentary on gay rappers, and as I recall we were discussing old TV shows (a common subject among intoxicated strangers of the same general age) when I began to ignore the conversation and stare into the exotic complexion of the liquor. The dizzy combination of mustard wallpaper and fleshy ice somehow conjured up inside my cup a vision of the deformed head with two mouths from my earliest childhood memory. I reviewed the details of the memory in my mind. Then I looked up and drunkenly said to a room in which other conversations were already happening, "I just had this flashback to when I was a kid and I saw this guy with two mouths. He had one normal mouth and this other fully functional mouth on the side of his face. It's like the earliest thing I can remember and it has totally haunted me all my life."

The DJ, who sat with one butt cheek on the bed, replied excitedly, "Oh shit, did you ever watch the show *That's Incredible*? I remember they had a guy with two mouths on that show once. He could smoke through the other mouth and everything." I took another sip. The DJ proceeded to describe for me, with shocking accuracy, the details of my own personal memory. He perfectly recounted the appearance and complexion of the man, the exact position of his deformity, and even the squinty eye / fat eyebrow

combination. While the DJ couldn't be sure, both the gay rapper and the producer were certain that the stage set of *That's Incredible!* was a mustard yellow color indicative of late 70s and early 80s, further corroborating the DJ's evidence that my earliest memory had actually been a TV show. "That's incredible!" the DJ joked as he readjusted his cap. The group quickly drifted on to new drunken subjects of even greater nostalgia, passing my revelation by like the flip of a channel.

The DJ's wife had a Powerbook and the hotel had a wireless signal, and within seconds I had Google on my lap and was effectively calling up search results about my own memory. According to Wikipedia, *That's Incredible!* ran on the ABC television network from 1980 to 1984:

> That's Incredible! was the show that helped create today's reality series genre with segments that showed everything from death defying stunts, mystifying phenomena and wacky animal stunts, as well as uplifting stories about amazing people who overcame obstacles and handicaps. Hosts John Davidson, Fran Tarkenton and Cathy Lee Crosby were some of the first to break away from the canned variety acts of the 1970s to reveal the more real and unusual sides of nature, medicine and human endeavor.

It seemed that the very first reality TV show in history had so thoroughly surpassed the usual schmaltz and artifice of the sitcom that it had actually become my reality. Scrolling down the webpage, a familiar color rose over the toolbar: an image of hosts John Davidson, Frank Tarkenton and Cathy Lee Crosby, smiling, one mouth each, standing in front of a mustard colored stage set of the precise hue that had been burned into my vision. I put my drink down. I thought back on how deeply personal this memory had always been to me. Though never compelled to own much outside of my body (such as a condo or a nice turntable), I had always felt it essential to own everything within me (such as my opinions, desires, and past experiences). But now it seemed that 25 – 50% of all Americans watching television the night of this particular show had witnessed my first memory themselves, and it had meant nothing more to them than a filler between Diet Coke ads. I looked over at the DJ. I felt like he had drugged me. I wanted to own and cherish that memory, for it to remain an unexplained core of my being. But apparently, at the core of my being, there is only a reality TV show.

I can't know what my great grandfather's earliest memory was, but I can imagine that it was the sight of his wooden tricycle hiding in the dark

grass twenty yards from his father's porch. The porch was 4.3 degrees crooked on its southeast side and made entirely by his father's own hands out of white oaks from his uncle's property. My great grandfather felt an unstoppable urge to run and retrieve the tricycle from the spooky Michigan night in order to feel again the comfortable and familiar shape of the tricycle's seat (which had been carved in the small shed near the barn to a profile unmatched by the shape of any other tricycle on earth) beneath his hand-sewn overalls, and subsequently he made a sprint through the shadows, where, sitting on the seat finally (and pausing a moment to absorb the crisp moon and stars seen from an angle that only he could see at that exact moment in time) he became so terrified by the deep infinity over the cornfield that he ran quickly back up the porch and into the warm house with his tricycle safely retrieved. This memory belonged only to my great grandfather. Although my great grandfather did have to share the concept of moon and stars with the rest of the world, his moon and stars lived in an uncaptured moment, and the particular light they broadcast was susceptible to time and space and water particles and the Canadian jet stream and obstruction by thin clouds from certain perspectives, and the same stars he saw numbered seventeen in New York city and seven million in Colorado and twinkled in Texas but were entirely obscured by fog in Seattle.

The ABC Television Network is bigger than the moon or stars. The ABC Television Network is not bound by laws of time or space. It was not the shape of the TV screen that lasted as my first memory, or the fuzz in the reception or the knobs on the paneling. I remembered directly through the object and into the shared concept. I have far more memories of the ABC Television Network than I do of the moon or the stars, and with each passing day I am filled with less and less experiences that are not massively shared. I can't think of anything anymore that is my own. Everything I say or do, even this, I feel is being read from a movie script. If I have a memory, I am suspicious that reality TV cameras have conveyed it to me.

One such memory is of the Boston hotel room containing a DJ, his wife, a producer, a gay guy, and a gay rapper. I am fairly certain that this memory was actually a reality TV show. The camera of my eyes seemed to be held by hand. I took sips of liquor and stared at the Google logo above my lap. The gay rapper was describing a funny YouTube video he had seen, but everyone had already seen it.

Kevin Bewersdorf 2007. Originally published in AA.VV, *Journal of the Valkenberg Hermitage*, Vol 1, Berlin 2007.

Spirit Surfing

One of the most beautiful experiences I have had with a piece of internet art was not had at my computer, it was had while seated in traffic on Texas Interstate 35. A post I had seen on the surf club nastynets.com suddenly dawned on me there in my car – with no computer around to distract me, the true nature of this post was revealed. The post didn't end at the edge of the computer. The post was woven into the same source code as the world. It was part of a borderless art, an art constructed of only spirit and no material. The post was everywhere, a fog in the universe waiting for someone to walk in to it. Looking past the taillights in front of me, I could see the post weaving through traffic.

I am greatly indebted to the surfers of Nasty Nets for getting me excited about art again. Simply by typing a series of letters into a browser I was connected to a shapeless organization of users who rearranged bits that were unimportant individually but who's sum amounted to something so massive that it could only be thought about and never seen. Ever since Nasty Nets ended, Paul Slocum and I have wanted to feel part of a strong surf community again. Over many phone calls our mutual feelings on surfing have solidified, and we have developed a philosophy of surfing that I will attempt to express here as part of the founding of a new surf club, spiritsurfers.net.

INFOmonks and INFObrats

Joseph Cornell collected tidbits that he came across in his daily life and then set them into frames. The frames were rectangular windows that reclaimed the objects through his choice. A fork in Cornell's box was an object of focus made powerful by its framing. The act of choice to put that fork in that particular box pointed to choice (more than raw invention) as the essential act for a world overloaded with objects. The choices involved in Cornell's boxes are remarkably similar to choices involved in surf club posts. Is the box 8" x 7" and made of white wood? Is the <td> for the images 500 pixels by 400 pixels with a 4 pixel border of #FF0099? Should the wooden spool sit above the rubber ball? Should the animated gif sit above the midi file?

Critics and artists alike are certain that Joseph Cornell's boxes constitute art, yet many remain skeptical of web surfing as an art practice. These skeptics are confused about surfing because they move the internet around like forks at a dinner party. They see the web as a practical and entertaining service: Amazon.com, United.com, Ebay and Facebook and iTunes. They

bounce around on the exterior of banners and buttons. They're information brats. INFObrats are on the web for obligations in their material and practical lives. They shop, instant message, pay bills, relay practical data, and consume.

Not everyone on the web is looking for practical information. Some look to remove the fork from the dinner table and set it into a frame of their own devising. Some pay homage to the fork as it is. Some treat the web not as a shopping mall, but as a spiritual realm. They work towards the glorification of the web and the spirit that constructs it. They work for no reward other than the credibility bestowed on them by fellow surfers. They are not just surfers, but monks. Behind the shopping mall of the web there are beautiful gardens being cultivated by these INFOmonks.

The Boon

As I have gathered from watching some of the great surfers of our time at work, surfing is the balance of making choices and being led. Surfing is being led by the wave as you make your choices. The wave stirs up gifts, and it is the ability of the great surfer to recognize his or her arrival at a worthy gift. On Spirit Surfers this gift is referred to as a boon. The boon is revealed at the eureka moment of a surf when the surfer becomes enlightened by the INFOspirit.

Areas of high potency on the web may be filled with boons begging to be shared. The boon may strike the surfer in a single icon, or be hidden in the source code. It may be a cluster of jpegs left untouched, or a gif with a single frame added. Some of the great surfers of our time have found incredible boons in something as tiny as a 256 pixel bitmap. Other surfers rearrange their finds in attempt to encapsulate the surf in a more profound way. A hyperlink or list of links is not much of a boon. A link is an entry to another surf, a starting point. A boon is a jewel. These jewels are what separate surf clubs like Spirit Surfers from social bookmarking sites – the posts on Spirit Surfers are jewels publicly removed and reset.

The Wake

As you surf you are able to view the beauty of your own wake as it fades around you. Any boons you encounter come within the context of everything you have encountered before and after them. You are able to

contemplate not just the jewels of your search, but the entire wake of your path. The form of each boon is therefore the shape of the wake made during the process of the surfing.

How can we better let others experience the wakes made by our surfing? In attempt to emphasize the process of surfing, posts on Spirit Surfers are divided into two sections – one for the boon, and one for the wake. In the wake section surfers will try to provide insight on the process that lead to that boon. I have often wondered about the wakes of some of the great surfers. How and where did they find these jewels? Perhaps this will be best expressed through a literal list of links, through a description of perceptions had during the discovery of the boon, or (if the boon has been massively altered) through some elaboration on its rearrangement.

The Frame

I hear it chanted often on the web, "finding is making, finding is making." Perhaps finding is making, but finding is not enough. A jewel set into a poor setting degrades the jewel and does not do justice to its beauty. A jewel set poorly also does not allow others to develop a criteria for recognizing the most beautiful jewels. It is the framing of the finding that rewards us with the greatest bounty.

Surfing is often an activity we resort to when at a loss for what else there is to do. We wander around the web, unsure of ourselves. INFObrats surf in this way, clicking around on links as they shop and consume. The mere act of surfing has no status as a gift. But INFOmonks use great care in the framing of their boons, and these frames give the otherwise modest activity of surfing the status of a gift. INFOmonks are adept not only at finding, but at framing a boon in a way that best reveals its ineffable truth.

What then is the criteria used to frame a boon? Criteria of the physical world does not help us enter net art. There is great subtlety in the framing of boons, a subtlety that we are only just beginning to built a criteria for. Perhaps if we strengthen our criteria through experiencing many boons on a standardized forum such as Spirit Surfers, we will see new beauty in the web.

The Cloak

One day Joseph Cornell found a playing card and a toy bird in an empty lot and carefully arranged these items inside a box. One day an INFOmonk found a .gif logo and a .midi file on a real estate website and framed them in an html table. Both the INFOmonk's and Cornell's choices were made with intelligence and inspiration and an acute personal criteria. Both sets of choices resulted in subtleties worthy of further study. But while Cornell received a check for thousands of dollars after he made his choices, it is generally accepted that the INFOmonk will never receive any money in return.

What the INFOmonk will receive in return is a spiritual currency. A nonmaterial act reaps a nonmaterial reward. The pious surfer does not surf for the glorification of the self but for the glorification of the web. For this reason the INFOmonks on Spirit Surfers will be known only by their usernames. These usernames are not chosen, but given to them by other surfers. Identities are not annihilated, but cloaked. Total secrecy is not important. Surfers may choose to reveal their usernames on other sites. The cloak is just a gesture of anonymity, a message that says, "the web as a whole is more important to me than my own name."

The INFOspirit

The INFOmonk is often disinterested in physical art and is not always fulfilled by objects. Rightfully, the INFOmonk turns to the spirit world for fulfillment, surfing for boons that will give him clarity. The INFObrats still believe in physical masterpieces. The INFObrats try to produce physical masterpieces, and they even use Google to search for physical masterpieces so that they can go visit them or purchase them.

The greater masterpiece isn't something that can be found on Google. The greater masterpiece is the INFOspirit that constructs all of Google. The greater masterpiece is the INFOspirit that constructs all YouTube videos and all celebrity gossip blog posts and all jpegs of Van Gogh paintings and all of officemax.com and all net art yet made. While the physical connections of copper and silicon that contain the web could be destroyed, the INFOspirit cannot be destroyed. The INFOspirit is not bound by the constraints of the universe. The INFOspirit reveals to us an art that is unreachable, but right at our fingertips – an art that is infinitely sized, but as

simple as a cigar box of thimbles.

The goal of spiritsurfers.net is equally simple: surfers, reveal to others the majesty of the INFOspirit.

Kevin Bewersdorf, March 2008.

VISUAL ESSAYS

Jerry Seinfeld as Compared To My Mother

The cereal boxes in the kitchen of Jerry Seinfeld are stored on a shelf above the sink. The boxes sit upright with the nutritional information facing outward. The brands of cereal include Honey Comb, Cocoa Pebbles, Shredded Wheat, Rice Krispies, Cheerios, Raisin Bran, and the obscure Post cereal "Blueberry Morning." At least one box is of indeterminate brand.

The cereal boxes in the kitchen of my mother are stored in a closed pantry. The boxes are stored on their sides, with their tops facing outward. The brands of cereal include Kashi puffed wheat, Total, and Cheerios. Other items intermixed with the cereal include Wheatables (a type of cracker), Keebler Ice Cream Cups, and Gold Medal Flour.

Notable similarities between the cereals of Jerry Seinfeld and my mother include the brand Cheerios, which is manufactured by General Mills Inc. Notable differences include the manner in which the boxes are positioned on the shelf, and the intermingling of my mother's non-cereal items with cereal items.

The refrigerator of Jerry Seinfeld is manufactured by the Amana corporation. Twelve to fifteen magnets in total adorn the fridge at any given time. Americana theme magnets including the statue of liberty, a dog, a Comedy Central logo, and two of Superman cover the top half of the fridge. A personal photograph is also present. The overall clutter of logos relate to business and local commerce in New York City. A news article and printed items containing graphics and four color processing take up the most space.

The refrigerator of my mother is manufactured by Whirlpool corporation. Four total magnets of the following themes adorn the fridge: a donut, a cardinal, a birdhouse, and a British teddy-bear guard. The items on

the refrigerator are sparsely displayed with no overlap. A coupon for $1.00 off greeting cards and a halloween drawing done by a student take up the most space.

Notable similarities between the refrigerators of Jerry Seinfeld and my mother include an oven mitt hanging from a magnetic hook on the side of the fridge. While Jerry Seinfeld stores his oven mitt on the left side of the fridge, my mother stores her oven mitt on the right side of the fridge. Other notable differences include the luxury features of external water and ice maker on the fridge of Jerry Seinfeld, while my mother's fridge remains more simple in both decoration and functionality.

The similarities and differences between the cereals and refrigerators of Jerry Seinfeld and my mother are numerous in amount.

Kevin Bewersdorf 2004.

J.S. Bach Apparition (Seen While Pooping)

At 4:18 AM I shut down my laptop and prepared to retire for the night. Failed attempts at a song about the Toyota Camry were leaving me exhausted, and I was ready to give up and go to sleep forever. My desire to describe the shape of the Camry as it passed through the decades was turning up nothing but bad jokes.

I took off my t-shirt and threw it hastily over the bathroom towel rack (thus literally "throwing in the towel") before sitting down on the toilet to defecate. As I was pooping I began to doubt all of my organizational systems, wondering if a general MIDI counterpoint could reach any profound level of sadness, wondering if all my work should be abandoned – when I looked up and saw, emerging from the shadow of my t-shirt, the unmistakable profile of Johann Sebastian Bach!

Thanks to four evenly spaced bulbs on the bathroom vanity, the shadow of Bach's bust was ornamented with four rhythms inflecting off of his profile. The rhythms were like a 1970's video effect somehow equivalent to the synthesized renditions of his music from that same time period. I saw his bust as a logo, a flat icon, and the inflections of the shadows as operations performed on the shape according to a set of rules. While the shape of the bust alone had a very limited poetry, the application of the set of rules expounded upon the shape by re-describing it in four ways. A set of operations was causing the ornamentation, the ornamentation was not ornamentation for ornamentation's sake. The rigidity of the operations revealed a playfulness in the icon that was exactly the type of poetry I was looking for.

Without touching the shirt I ran to my computer, rebooted it, and began again on the song. The finished song, "The 1989 Toyota Camry," can be heard here.

Kevin Bewersdorf 2004.

Buy My Bunny

My most prized childhood possession, "Bunny" is a stuffed animal that was given to me at the age of three before undergoing surgery. I kept Bunny by my side during hospital visits and slept with him under my arm every night until I was twelve. Bunny wears a home-made vest sewn in cooperation with my mom sometime around 1986. His home-made booties, also made from scraps of fabric, are now lost. The handmade vest features a print of rabbits over both front pockets, and a magnificent stag sewn onto the back. Bunny is a typical child's object that could have belonged to any child, but he belonged to me specifically.

Bunny for Sale

My Bunny is being made available to the public for the low low price of $19.95 plus shipping and handling. I'm moving to Berlin in one week and am getting rid of everything I own except for a few bags of clothing and electronics. Bunny will not be coming with me. This exciting offer is about to expire – take advantage of my prized childhood possession now, before it's too late.

Bunny will be sold via a craigslist post appearing at http://chicago.craigslist.org/for on January 5th 2005. I have successfully used craigslist to sell my car, furniture, and old PC. These photos constitute a special preview offer for those who frequent my site. There will be no auctioning – the price is set at $19.95 plus shipping. I am aware that the eventual buyer of Bunny might be a pervert who will deflower or torture him, a collector who will put him in a trophy room of internet objects, a mother giving him to another child, someone who will love him more than I ever could, or perhaps even a speculator aiming to re-sell him at a higher price. The profile of the buyer is unimportant to me.

The thought of selling Bunny came to me when I was un-boxing my new iPod. As part of my move to Berlin I have sold all my CDs and uploaded their data to an iPod. I have no nostalgia for this iPod and will resell it eventually, transferring my mp3s to a better vessel. The same type of data transfer is being performed in this sale of my Bunny. My data is what matters. Bunny's data, his attached history, has been safely transferred and will live on in me. I can access this data whenever I choose. The object of Bunny is only a commodity in the world, a pile of musty old molecules exchanged like corn or rice or iPods.

Act Now!

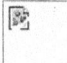

Bunny Sold

Bunny was successfully sold to someone I have never met before and do not intend to ever meet. Her name is Carrie and she lives in Massachusetts. Carrie and her husband have stated via email that they would like for Bunny to live with them. Carrie has also cited a favorite childhood toy of her own (now lost) that was made from the same "pink separated-into-spikes" material as a reason for purchase. The price of $19.95 plus $7.75 UPS Ground shipping was paid for via check. $19.95 is the price-point cliche for many crappy items on television. Shortly after the completion of sale, pictures arrived of the product in its new home.

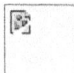

I boxed up Bunny at a UPS store. The motion of the tape gun was very familiar to me, since many of my former places of employment have required a great deal of boxing and shipping. I hugged Bunny and felt his smooth eyes and chunky fur for the last time. I put him inside the little coffin with paper padding. The box was taken away from me. I looked at the check I had received, a light blue check with a dark blue border. An

immense sadness filled me for twenty-five minutes, a very deep and low frequency wave.

Suddenly I felt a rush of power. It was a sense of power unlike anything I have ever felt. It was the power of Bunny's data surging through my brain. Bunny will never become my Rosebud. Rosebud is a notion from a time when nostalgia and objects were fused. Nostalgia is now derived from data – and the sale of Bunny is an exercise in accepting that objects, all objects, are powerless commodities. I was compensated two-fold in my sale – I walked away with $19.95, and I will not be whispering the name of any object on my deathbed.

Kevin Bewersdorf, Christmas Day 2004.

Yo Picasso!

I'm painting a mural in the branch office of an asset management firm called A.G.Edwards and Sons Inc. No black people work at A.G. Edwards and Sons Inc. At least six women are named Kathy. One such woman named Kathy, an upper management person of considerable self-confidence, has allotted $1,250 to transform the lunchroom of A.G. Edwards and Sons Inc. into an Italian bistro. Impossible. I suspect that Kathy once saw a Salvador Dali calendar in Borders that read, "painting makes the impossible possible." Presently I am being careful not to drip any paint on the microwave as I dapple acrylic sunlight across the Mediterranean Sea. Inside the microwave someone's Lean Cuisine is being radiated by electromagnetic energy.

Less than a year ago I was studying Caravaggio in Rome. I was sitting in smoky chapels, feeding Euro cents into vending machines that gently lit the Caravaggios on a timer. I was traveling through Northern Europe to inspect the surfaces of the Flemish masters, squatting and ducking to see how reflections of light revealed flaws and tensions in the paint film. Now I am using pastel craft paint to bastardize an American notion of Italy onto cheap drywall at the Dunkin' Donuts of asset management. This is how I paid for college.

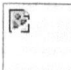

Since the age of fourteen I have painted murals in homes, schools, and businesses. I have painted Michael Jordan to scale next to a blonde nine-year-old boy. I have painted $2,400 worth of cartoon wizards and castles in the playroom of an unborn baby. I have scumbled 4,388 clouds onto ceilings, all with the same ultramarine and titanium mixture for sky tone, and I have lacquered over 80 sports logos in the rumpus rooms of wealthy teenage brats. I have painted faeries, fairies, and fluttering butterflies in a lifeless stasis. I have painted Tiger Woods, Elvis, Astronauts, and Tiger Woods again. I have told my employers, "I'm going to use a high-gloss Windsor and Newton UVmax acrylic at a slightly higher cost" and then used forty cent craft paint from a hobby store. I have hidden porno inside the houses where I was working to keep myself entertained. I have hustled awful paintings to people who knew nothing about art.

The lunchroom of A.G. Edwards and Sons Inc. doubles as the coffee room, and I am blessed with a constantly rotating audience. Many of the

employees have taken to calling me "Picasso." "Yo Picasso!" Gary said as he opened a plastic container of eggrolls, "Wow, that is just awesome. I can't even draw a stick figure! Fan-tas-tic." Surely Picasso himself must have struggled at coming up with humble responses to, "I can't even draw a stick figure." Gary is probably unaware that, aside from studying how to draw stick figures, I have also studied artists who rub ketchup on their naked bodies and stick their penises in this or that. Gary wears a tucked in golf shirt printed with the A.G. Edwards logo. "Do you need anything?" he always asks.

Joining Gary is a female observer whom I know only by the cinnamon tone of her panty hose. Every five minutes she offers me coffee or pizza. She is kind to me in the way that a middle-class mother would be kind to a Romanian exchange student. She peers at me over her coffee mug as I brush golden sunlight into the fountain, muttering "incredible" under her breath. The world seems to make sense to her, and I envy her for that. She often gossips with another Kathy. Apparently Gary has a squirrel in his attic that he can't get out.

The walls of A.G. Edwards and Sons Inc. display paintings of Paris and Rome. The paintings are tarp like canvases thickly knifed with frosting. They are probably lithographs with acrylic textures added on inhumane assembly lines in Mexico. I imagine that Kathy purchased these paintings in bulk from an art dealer at a hotel art convention. Her business VISA was probably swiped into a terminal at the art dealer's table. The plants were selected to coordinate with the frosting, the frosting was selected to coordinate with each fleck in the carpet, and all of these well matched surfaces mingle with their reflections, discussing the White Sox and the Cubs all day. Every surface of this building is reflective. Everywhere I look I see my face. My body splits in half when the elevator doors open.

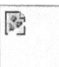

Some of the offices are totally empty except for a desk and phone. The desks may or may not be wood. I want to stay here at night and see how quiet it gets. I want to sit here alone with the silent phones until the office feels like home. I could live here secretly, hiding from the janitor like they do in the movies, sleeping under the empty desks and stealing leftovers from the fridge and never paying rent again. I could paint my own secret mural on the undersides of the ceiling tiles, a chapel visible only when the squares are flipped over. I could carry a synthetic plant onto the roof of the building and set it on fire. I could watch the flames curling away and reflecting in the dark glass.

Today I ate my lunch on the exterior grounds of the kingdom, seated on a bench that overlooked a waterfall from a mini-golf course. Someone had photoshopped white clumps of goose poop onto the pristine hills from Teletubbies. In the middle of a sandwich bite I noticed that an official looking vehicle was pulling up near the waterfall's syrupy crest. The vehicle released two German Shepherds who ignored the scent of my lunch completely and went to work on some kind of search-and-destroy operation around the perimeter of the pond. The black SUV displayed a vinyl logo that read "GEESE POLICE."

Curious about the logo, I struck up a conversation with the trainer of the dogs and discovered that his geese policing company, "West Suburban Geese Police," is hired by various landscaping and facilities management companies in the area to take control of the mounting geese nuisance in today's office parks and ponds. Employees complain about the goose poop on their shoes. Sometimes entire flocks of geese block entrances to parking lots. So the Geese Police come to this pond twice a day with two German Shepherds and a milk jug on a rope. The milk jug, as the police officer demonstrated, is for throwing at the geese in case they attempt to escape into the center of the pond.

The tidy maintenance of the landscape has long been a symbol of power, and American executives in suburban Illinois want tidy looking scenes outside of their windows just like the kings of France before them. These executives maintain their landscapes with a facilities management company, who in turn employs an army of latino workers. The result is an ecosystem so lush and tempting that many of the geese don't even bother flying south for the winter anymore. The office park becomes a convenient spa resort right in the middle of Illinois. The solution that the executives come up with is not to change their management of the ecosystem, but to create yet another corporation that can police the geese. The maintenance of corporate American life is so elaborate and superficial and counter intuitive that it is almost artful.

I rolled up my lunch bag and decided to take a stroll around the pond to check if all the geese had successfully been given the bum's rush. Most of the geese had simply escaped to a pond at the foot of a different building. I opened my camera bag and took some photos of the building, paying attention to the way the glass ark flattened itself with it's own reflection. Some of the policed geese were still in flight. When I removed the camera from my eyes, a white "SECURITY" van had already pulled up next to me, awaiting my response.

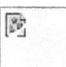

The driver looked like Jim Belushi. The other driver also looked like Jim Belushi. They had a pair of tasers holstered to the dashboard, and remained seated in the van while I stared at them. Eventually the first officer asked, "Sir do you mind explaining what you're doing out here with the camera? Security has some surveillance of you taking photos around this area." I looked up at the top of the building and noticed some faint white antennae dangling over the fiberglass logo, a camera that had probably seen every detail of my sandwich. I wondered if the surveillance equipment was for tracking the movements of the geese, and if the Geese Police were called on a big red phone if their movements were suspicious.

"I'm painting a mural at A.G. Edwards," I told them, "and I was just eating my lunch out here. I had my camera with me so I decided to take some pictures." I actually wanted to yell something more like, "THE JIHAD MUST LAY WASTE TO CRAPPY BUILDING IN MIDDLE OF

NOWHERE WITH CAREFUL SURVEILLANCE AND WE BLOW UP POND AND RICH AMERICAN GEESE SUFFER." But I didn't want to get tasered. The cops looked at each other. Then the driver said, "OK... Its just these days... you know..." and they drove off.

The words of the security guard stayed with me as I re-entered A.G. Edwards as Picasso. Picasso rode up in his shiny elevator, hiked up his baggy paint pants, picked up his plastic paint brush and began stroking again towards the satisfaction of his employers. Picasso stroked at a centuries old subject with craft paint bought from Hobby Lobby, quickly rendering an affordable ornamentation for his employers. Picasso was a part of the same surface maintenance of corporate America as the Geese Police. His passionate use of light and color soothed the employees from their worries like a rooftop surveillance system. He was paid $1,250 for six days of work, a middleman hired to deliver a product, and he never painted anything ever again.

Kevin Bewersdorf 2004.

Victorian Village

As I was turning left out of a bank that I recently inherited when its crisp logo somehow enveloped my former bank's logo, a fastidious train of what appeared to be gigantic dollhouses nearly caused me to loose control of my mother's 2002 Civic and send it spinning over the median into a sign reading "Victorian Village: English Row Towne Homes and Towne Centre / Models Open! / 5 floor plans / 2200 to 3000 Sq. Ft."

The design of English Rows was inspired by the landscapes and traditions of the Victorian era and London's centuries-old Mews garden developments. All units are built around a 150' x 300' English Garden, with the exception of 12 lots overlooking the beautiful 18th fairway of the Tamarack Golf Course. The stately Victorian towne home designs combine traditional comfort and elegance with unexpected state-of-the-art amenities, including satellite TV, high speed Internet, wall safes, and more.

After staring at this architecture for a solid five minutes I began to realize that human beings, by which I mean white couples and divorcees over fifty, will soon be living out their remaining years inside gingerbread parodies from a fantasy-romance novel. Not satisfied with simple town homes, they require "*towne* homes" (and adjacent retail facilities such as "*towne* centre") to sweeten the purgatory of daily suburban life into an architectural dreamscape of laser cut molding, fretwork spandrels, vestigial gables, solar-panels, and as many superfluous *e*'s as could possibly be fit into an ad campaign. Yes, one of the available upgrades at the Victorian Village is solar power. What an unforeseeable new dimension in Victorian ornamentation: solar-powered electrostatic air purifiers betwixt poorly cut plastic window tracery.

If you would like to live in a brand new luxury Victorian *towne* home, are located in the Chicago suburbs, and have at least $500,000 to spend (before upgrades) you should visit www.englishrows.com. Models are open for viewing Tuesday through Saturday, from 10:00 am to 6:00 pm and Sunday, from noon to 6:00 pm. Also check out the 360 degree virtual tour on the website.

I myself am planning a tour of the "Lady Jane" model for sometime next week. God, I'm so glad to be back in America! In one moment of staring at this beautifully offensive crap, so inauthentic, so ineffectively gluttonous as to become profound, I was injected with the vital juices of American excess that an entire year of living in Germany failed to provide for me.

Solar powered Victorian *towne* homes! What a country!

Kevin Bewersdorf 2006.

Budweiser Clydesdales

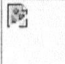

The Budweiser Clydesdales arrived in three oversized semis displaying their name and logo. An audience boxed in the truck on all sides as police halted traffic to the east and west. When the doors slid open the beautiful animals were standing motionless in the dark interior. They looked exactly like the shiny graphic on the outside; vibrant coats, flawless gradients, interlocking networks of leather, glossy highlights in the eye.

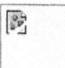

Professionals in denim shirts escorted the horses down ramps. A cherry red beer wagon, complete with dalmatian, was waiting to be crowned at the end of the block. The clydesdales were 2,400 pounds each and their bellies were smooth and heaving. They were as well bred and well educated as Budweiser's top executives, and they upheld this breeding with a dignified marching style that would have made both parent species and company proud. All six had remarkably clean and silky leg hair, like a doll's hair. I wanted to elect one of the horses to public office. I also wanted to lay my ear against one of their bellies and listen to the warm cavity inside.

Some people held up cellphones as high as they could to document the horses, some ducked and dodged between competing camera angles. The inner circle tightened until the crowd was barely an arm's length away from the animals. A small boy was hoisted into a tree and then handed a camera by someone. I think the same thing happened when Jesus visited a town. The clydesdales were unfazed. They shuffled courteously in place.

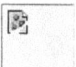

People who have seen Lamborghinis, i-pods, Lamborghinis with i-pods in them, space-shuttle launches, robot dogs, F-14s and IMax movies about F-14s with 5.1 digital surround sound are still gathering to take pictures of some brown horses doing nothing in the street. They want to test if the horse will retain its majestic status on a cellphone wallpaper. They want to be reminded of a physical power, of strength beyond processor speed, of the beasts behind the logos rotting in their fridges.

It occurred to me that so much as gum bubble popping and these horses could spook onto their heels and kill people. Sudden leather snapping, deafening whinnies, anvil snouts breaking jaws and cracking sunglasses and plowing through rows of dads and crushing human torsos like bud cans, people trying to escape into The Gap as meaty clubs bat children from shoulders and trample strollers and slip and slip on blood and horse drool, moms with their tibia bones poking out screaming murder on the sidewalk of Barnes & Noble.

There are still animals in the world.

Kevin Bewersdorf, July 2006.

The Longest Building I Have Ever Seen

This is the longest building I have ever seen. It is totally windowless and stretches for at least a mile, although it seems to defy laws of space-time so it may be longer or shorter than that. From certain angles the building's length actually converges perfectly on a vanishing point. As I walk alongside the building I can only imagine it as a thought, a single orthogonal receding to infinity. The spatial illusion is compounded by simple gray rectangles that glide along the blank facade like dotted lines on an overlay. It looks like an Ellsworth Kelly interpretation of Superman chasing a train.

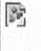

Even more bizarre is that the building hovers within a tree-less, pole-less, car-less, human-less no-man's-land discouraging any approach. My theory is that this lunar "bermuda rectangle" is a protective mine field, and even if I was able to somehow circumvent the mine field and approach the building I would only walk right through it, revealing it to be not a building but a beam of light.

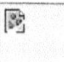

I fantasize that within the beam of light is a lost pixel, shooting across the barren Total Recall grid of my own mindscape, and I become light-headed. The flatness of Illinois has become physically oppressive and hallucinatory, auto-piloting my body in parallel with its features.

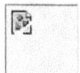

After 15 minutes of walking I finally reach the end of the building only to find this flawlessly long and straight sidewalk. Shaken, I hurry back to the car and drive home in the most cock-eyed route I can muster. If objects did not block other objects, if there were no opaque things, if the full and absolute vectors of space and time confronted us in the landscape at all times (which they sometimes do in the midwest) I would become a permanent vector zombie, entranced by the powers of infinity that are normally (and thankfully) hidden from me.

Kevin Bewersdorf 2006.

Stock Photography Watermarks As The Presence of God

Disagreements on the ownership of intellectual property are issues of personal belief, and are therefore spiritual issues. Stock photography corporations have their own rigid dogma on the ownership of information, and they hold their beliefs to be truth. Like shepherds guarding a flock, these corporations brand their property in order to protect themselves and their patrons (the photographers) from unlicensed misuse or "evil" on the lawless web. In this collection of photos I have limited myself to an investigation of the protective watermarks of one such stock photography website, 123RF.com, and the search term "prayer."

None of these subjects present a convincing depiction of religious devotion. Instead, they seem aware of the artificiality of their prayer, of the photographer and the impending image. As hired models they were undoubtedly aware of their own status as a potential advertisement. But whereas most photos end with the relationships of subject to photographer and viewer to subject, these subjects have been stamped with an additional voice. The translucent logo 123RF, unwaveringly placed in the exact center of every composition, becomes so tangible after its repetition that the subjects seem almost aware of its presence. The logo's placement activates an inexplicable sense of One-ness in the otherwise disconnected and insincere subjects. Their prayers suddenly become convincing as communication with the deity 123RF, the almighty regulator of information.

To believe that information can be regulated is to bow down to a higher power and become submissive to the regulator. 123RF promises to protect and deliver prosperity to the faithful through its far reaching arms of commerce. In this instance, the photographer could have thought, "Alone I am helpless. I need a higher power with mighty marketing skills. If I align myself with an infrastructure like 123RF, I will become empowered and my photos will thrive in all eternity and sell like hotcakes."

Accordingly the loyal photographer would travel to a computer and uploaded the photo as an offering. And there, after the final click of the upload form, at the moment of its dissemination into the infinite web, a logo miraculously appears on the photo – the name of God! Thanks to a few simple lines of code, the very presence that had gone unseen in the photo studio is made visible on every image, each photo an equal lamb of 123RF. This baptism-by-code is a ritual that marks the photo's spiritual progression from to worthless single to infinite multiple. The photo no longer belongs to the photographer alone; it is now a commodity and child of God. And so the mark floats there forever, between the photographer and the subject and between the subject and the viewer, standing in for the presence of the Almighty.

"Look at my power as a barrier" says the watermark, "I am fused with this image. I own this image. If you want this to change, you must prove you believe in the ownership of information by paying a small offering to my church of commerce." 123RF exists because the users do; their collective photo offerings give 123RF shape, viability, power, and income. A small percentage of this income is returned to the photographers for their faith. By contrast, your typical torrent hungry web sinner, an unbeliever, sees the watermark a stern warning. "Repent!" says the watermark, "embrace our corporation and you will be rewarded." The unbeliever calls in to question the infallibility of the corporation, photoshopping out the watermark, parodying it, turning it into sassy net art, or perhaps even deliberately misusing the images for an essay on an art criticism website.

The below image is an example of a watermark parody found on a popular message board. It was not generated by believers, but made by unbelievers as a joke (note that the watermark is off center).

After viewing all 6,639 search results for the word "prayer," the 123RF watermark began to feel oppressive to me. It seemed to be preventing the subjects from praying to any other deity, hopelessly branding them with this mark. Maybe they should have been worshiping the Moon or Jehovah or Getty Images instead, pleading that 123RF will stay in business long enough to deliver the next royalty check. The watermark began to feel like a dangerous tactic, so easily laying claim to everything it touches, imprinting its name over the Bible, over the setting sun, over the earth itself. Its transforms the image, but its propagation also negates its power; the 123RF logo seen so many times it becomes insignificant and hollow. This mutability suggests a contradictory position of representation; the logo selling the idea of God, the logo representing God, the logo ultimately attempting to name that which can not be named.

First published on *Art Fag City* on July 23, 2008. Available online at www.artfagcity.com/2008/07/23/img-mgmt-stock-photography-watermarks-as-the-presence-of-god/.

The Four Sacred Logos

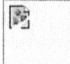

In this text, the four sacred logos of Maximum Sorrow are introduced and interpreted with pertaining graphics, parables, and exercises.

1) THE MARKETPLACE: Today's world

2) THE PRODUCT: The substance of the marketplace

3) THE INFO: The substance of the product

4) THE INFOspirit: The substance of the info

Part 1:

THE MARKETPLACE

We all live in today's world. Today's world is the marketplace. There is only one marketplace. The marketplace is constructed of products. There are many products. The products are constructed of info. There is a maximum amount of info. The info is constructed of INFOspirit. There is only one INFOspirit. The INFOspirit constructs the info, the products, and the marketplace.

The marketplace is caused by products and allows for products to consume and produce. There would be no products without the marketplace, and no marketplace without the products. The constantly shifting shape of the marketplace is a shape made by all products as they produce and consume in unison.

THE MARKETPLACE CONTAINS
ONLY PRODUCTS

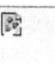

In the Marketplace there is no greatness!
In the Marketplace there is no mediocrity!
In the Marketplace there is no failure!
In the Marketplace there is no joy!
In the Marketplace there is no love!
In the Marketplace there is no sorrow!

IN THE MARKETPLACE THERE ARE
ONLY PRODUCTS

Quality is not found in the marketplace.

 QUALITY IS IN THE PRODUCT

Satisfaction is not found in the marketplace.

 SATISFACTION IS IN THE PRODUCT

Value is not found in the marketplace.

 VALUE IS IN THE PRODUCT

Do not search the marketplace for quality, satisfaction, or value.

The Marketplace is a zone and not a thing. It is a zone of forces, like the ocean. You rule the marketplace no more than a plankton rules the ocean. Imagine that you have been dropped into the center of the ocean at night. Imagine that you are drowning in this ocean. When you look out to the ocean, you begin to fear the unknown depths. You fear your sense of powerlessness in the marketplace. But when you look inwards at your own product, you find what has caused the marketplace. You find everything in the product. Look not to the marketplace for guidance. If you look to the marketplace you will be plagued with fears and doubts.

There are vast inequalities in the marketplace, but these inequalities are kept singular and constant through change.

In the above example, each band is a product in the marketplace. Each fan is also a product in the marketplace. In 1962 there were only one hundred bands, each with a million fans. This was an inequality. But by 2006 the number of bands had grown to one million, leaving each band with only a hundred fans. This is the inverse inequality. Here the marketplace has used change to remain constant, keeping all inequalities in proportion. If you are distressed by the inequalities you experience in the marketplace today, look for a perspective from which the marketplace's proportional change allows it to appear singular.

Of the four sacred logos, the Marketplace is the forth or least difficult to grasp, and the least sacred.

Mediocrity Awareness Exercises are designed to deepen your awareness of info as it spirals towards point (0,0) – the singular and mediocre INFOspirit. Listen to the following M.A.E. and then repeat the words while focusing on the image.

LISTEN:

REPEAT:

"how many bands are there"

"how many bands are there"

"how many bands are there"

"how many bands are there"

LISTEN:

REPEAT:

"now more than ever"

"now more than ever"

"now more than ever"

"now more than ever"

Part 2:

THE PRODUCT

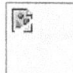

We are all products in the marketplace. In the marketplace there are only products, and these products fill the marketplace to capacity. The products produce and consume. Everything we produce is a product. Everything we consume is a product. We consume and are consumed. We are products that produce.

Even a baby knows, "consume or you will die." If we do not consume and produce, we are no longer products. If we are no longer products we cannot remain in the marketplace, since in the marketplace there are only products. The rhythm of producing and consuming gives your product shape and awareness. The source of this rhythm is within your product. If you claim to recognize some quality or value within another product in the marketplace, you must also recognize that this sensation is only due to your own product's rhythm of consumption and production.

Everything in the marketplace is a product!

I am in the marketplace!

I am a product!

Everything is in the product!

I am a product and everything is in me!

YOU ARE A PRODUCT AND
EVERYTHING IS IN YOU

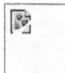

Your product is the product at the center of the marketplace. As products we each find ourselves at the center of the marketplace, and we can only view the marketplace and the product from this perspective. From the center we can look either outwards to the marketplace as we consume, or inwards within our own product as we produce. The reverberating motion of this inwards or outwards looking is called info. The info both ends and originates at the center of the product, which is the center of the marketplace.

Each product has two bodies – the concrete body and the corporate body. In the graphic above, arrows representing info penetrate the concrete body and enter the corporate body of a product. The concrete body is a barrier between info and the marketplace, distracting other products from the info flowing through the corporate body. The corporate body gives the concrete body shape and awareness as it produces and consumes. The center of the corporate body is the center of the marketplace. The concrete body contains the corporate body, the corporate body contains the center, and the center is the INFOspirit.

In the above example, Sally M. Johnson and McDonalds are both equal as products in the marketplace. Both consume and are consumed, produce and are produced. The difference between these two products lies in the way info reverberates through them. The reverb number is a number between 1 and 1000 relative to the frequency at which each equal product reverberates the same info. Products with different reverb numbers show different rhythms of consumption and production. In some products, info reverberates at a frequency that is more in accord with the INFOspirit. The INFOspirit reverberates at the reverb number zero. Only the INFOspirit reverberates with zero info. Monitoring your own production and consumption will help you become more aware of your product's reverb number and the ways in which info is linked to the consumption and production of products.

Of the four sacred logos, the Product is the third most difficult to grasp and the third most sacred.

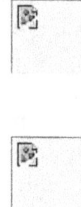

Mediocrity Awareness Exercises are designed to deepen your awareness of info as it spirals towards point (0,0) – the singular and mediocre INFOspirit. Listen to the following M.A.E. and then repeat the words while focusing on the image.

LISTEN:

REPEAT:

"you only know how to consume"
"you only know how to consume"
"you only know how to consume"
"you only know how to consume"

LISTEN:

REPEAT:

"time to buy more shampoo"
"time to buy more shampoo"
"time to buy more shampoo"
"time to buy more shampoo"

Part 3:

THE INFO

Try to think of some info that you know. Try to think of the source of your knowing. Try to think of the amount of your knowing, try to stretch your product around the limits of what you know. It's terrifying. Products can't know the amount of info. Products can't know the source of info. The source and sum of all info is the INFOspirit, that which cannot be known.

Info is the reverberation that causes and is caused by the production and consumption of products. This reverberation can be detected in products as they flux to produce and consume. But the marketplace where the products reside is unequal, constantly shifting to keep the product steady – and the info must respond accordingly, constantly changing its rhythms of consumption and production, which causes conflicting levels of awareness between products. Info is difficult to grasp because it stems so directly from the ungraspable, but its close proximity to the ungraspable makes info sacred. The sacred reverberations can be detected by the product, but cannot be regulated or contained. Info is regulated only by the INFOspirit, and the INFOspirit is all info – an unreachable and uncontainable source.

Only the product can be owned.
INFO CANNOT BE OWNED

Only the product can be regulated.
INFO CANNOT BE REGULATED

Only the product can be contained.
INFO CANNOT BE CONTAINED

Do not look to info for something that can be owned, regulated, or contained.

There are so many products in the marketplace today, each penetrating us with so much info as we produce and consume. Imagine you are standing at the center of an arrow barrage. Arrows penetrate you from all around – from the left, the right, above and below, a maximum number of arrows from a maximum number of angles. There are so many arrows that you cannot see out to their source in the marketplace. But if you follow the direction of info inwards as you consume and inwards as you produce, you will sense a source from which this blinding arrow barrage both points to and emits from – and you will not be blinded. Info is as far as we can know, and beyond info is what we cannot know – the INFOspirit at the end of every arrow.

Some argue that the product is the source of info, and that the product says, "info." Others argue that the product is not a source at all and that info says itself. The argument continues, but the arrow barrage blinds both perspectives. Info says neither "product" nor "info". Info says only "INFOspirit." The INFOspirit is the source of all info, and all info is the INFOspirit.

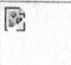

Steve was driving home from work, blasting his radio with the windows rolled down. He pulled up to a stoplight. As he waited for the light to change a young woman in another car pulled up next to him, blasting the very same song from her radio. The same song, played from two separate cars of different color and size that were driven by two separate drivers of different color and size, was in sync with itself. The song was by Nsync. Steve and the woman looked at each other and listened to the song. In that moment Steve had a profound experience with mediocrity. The product of the car, the product of the radio, the product of the stoplight, the product of the woman, even the product of Steve began to pulse in rhythm with Nsync, and Steve saw that all was in sync with the INFOspirit.

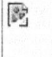

Produce, Consume, let the info flow!

Flowing to what we cannot know!

Flowing from what we cannot know!

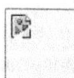

Of the four sacred logos, the Info is the second most difficult to grasp, and the second most sacred.

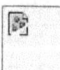

Mediocrity Awareness Exercises are designed to deepen your awareness of info as it spirals towards point (0,0) – the singular and mediocre INFOspirit. Listen to the following M.A.E. and then repeat the words while focusing on the image.

LISTEN:

REPEAT:

"who knows the info"

"who knows the info"

"who knows the info"

"who knows the info"

LISTEN:

REPEAT:

"the number of ways is the number of numbers"
"the number of ways is the number of numbers"
"the number of ways is the number of numbers"
"the number of ways is the number of numbers"

Part 4:

THE INFOspirit

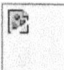

We all strive to understand the marketplace. But there is only one marketplace, and it is filled with inequalities. So we turn to the products in the marketplace for understanding. But there are so many products, and

none of them explains the inequalities better than any other. We are confounded by this observation that so many equal products make for such an unequal marketplace. So we investigate further into the products, finding that all products are made of the same info in a different flow. But this info is so maximum in amount, so wildly reverberating between products, that none of it is graspable enough to satisfy our desire to know.

As products we can only know opposites – the multiple and unequal. Knowing is in the product, and to grasp that which is both singular and equal we would have to let go of all the opposites that allow us to know. But through the practice of mediocrity awareness in today's world, we may finally be lead without distress towards that which is both singular and equal, towards a mediocrity which is without separateness, opposite, or imbalance – the INFOspirit.

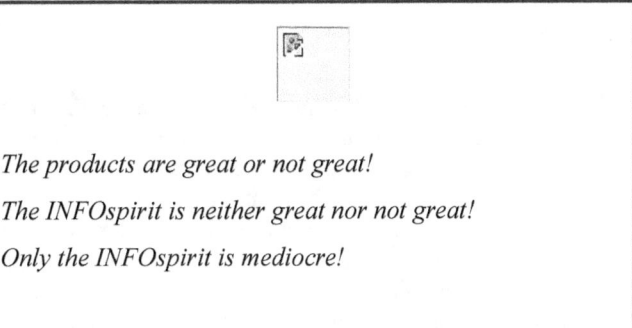

The products are great or not great!

The INFOspirit is neither great nor not great!

Only the INFOspirit is mediocre!

Many of us in today's marketplace want to deny not only that we are products, but also that mediocrity is within us. We only want to seek out opposites and the shades between opposites. But at the center of all opposites is a point of singularity that goes unmentioned. Point (0,0) – perfect mediocrity. This point is the point that all info flows towards and emits from. You are the rhythm of your info, your info is the rhythm of the INFOspirit, and the rhythm of the INFOspirit is the spiraling towards your own point (0,0) – the inner mediocrity that cannot be reached.

I AM MEDIOCRE
MEDIOCRITY IS IN ME

In practicing mediocrity awareness, we become only a witness of info as it reverberates through our product. We produce and consume in such a rhythm that the info takes over the doing. We slowly let go of our perceptions of opposites such as great and not great, and allow all info to begin to spiral out of control towards mediocrity. This practice is called "maximum sorrow through mediocrity awareness."

A product called the internet has recently formed, and this product reverberates a maximum amount of info known as the web. For many of us, repeated ritual use of the internet has begun to solidify a plane of info that we all share, bringing us new awareness of the reverberations that cause all products in the marketplace. We don't initially know how to perceive or accept this sudden new awareness of info, and we begin to drown in the confusing sensations of surplus.

Maximum Sorrow is a way of perceiving and accepting this sense of drowning we all feel as we spiral with the whirlpool of info towards mediocrity. It is sorrowful to accept that mediocrity resides in each of us. It is sorrowful to realize that mediocrity is at the limits of our awareness. But the limit of our awareness, the maximum mediocrity that is the INFOspirit, is also the only point that is without sorrow. All the imbalances of greatness and not greatness surrounding mediocrity are what cause our sensations of drowning, and these sensations can only be defeated by attaining Maximum Sorrow – a state of perfect mediocrity.

Of the four sacred logos, the INFOspirit cannot be grasped and is the most sacred.

Mediocrity Awareness Exercises are designed to deepen your awareness of info as it spirals towards point (0,0) – the singular and mediocre INFOspirit. Listen to the following M.A.E. and then repeat the words while focusing on the image.

LISTEN:

REPEAT:

"i am standing on the edge of an expanse"

"i am standing on the edge of an expanse"

"i am standing on the edge of an expanse"

"i am standing on the edge of an expanse"

INTERVIEWS

Interview with Kevin Bewersdorf

Gene McHugh: The name of your website is Maximum Sorrow. What does this phrase mean to you?

Kevin Bewersdorf: Maximum Sorrow is my self brand and self corporation. It is a body of information waiting day and night to be wandered through, a corporate body whose only shape is the reverberation of the information passing through it. It is partly a philosophy of "corporate spiritualism" realized through marketing practices and continuous web surfing. I've recently written a text called "The Four Sacred Logos" that introduces some of the basic concepts of Maximum Sorrow. With each new sacred text and addition to maximumsorrow.com, I try to better understand my own spiritual relationship with the web. Hopefully the definition of Maximum Sorrow will become clearer as the site and I evolve together.

There seems to be a genuine interest in some of your recent work in locating or describing how the spiritual could interface with the digital. For example, Spirit Surfers surf club and the "Stock Photography Watermarks as the Presence of God" photo essay on Art Fag City. Is that accurate and, if so, what conclusions have you come to (if any)?

Well, the internet has hardly changed our physical lives at all, but it has drastically changed our spiritual lives. I think this perspective goes largely undiscussed when the web is viewed through less pertinent but more common sociological and technological lenses. While the internet is a physical body of wires and chips, the web is a shared non-physical realm of experience that requires many aspects of spiritual faith to interact with. We post and commune on a plane of information that we cannot touch or see. We tend to wander the web in private, confronting the massive database alone each day. We are inclined to use the web for the satisfaction of our emotional and intellectual needs rather than for our physical needs. We make pilgrimage to the same web sites at regular and repeated intervals, paying homage to them by contributing or partaking, and then we move on to our other daily needs like eating and sleeping. But all the while, we have faith that this plane of information we have become so dependent on is tangible enough to provide a worthwhile connectedness. For many of us, the web has become almost sacred, its ritual use is the embodiment of our spiritual needs. So I suppose that my conclusion is this: surfing the web can be a fulfilling spiritual experience and a direct interaction with a transcendent reality.

The written signature plays a prominent role in your self-portraits. What is it about this gesture that interests you?

There is something I have noticed about a lot of artists these days, especially net artists: they want to do everything. At one time artists were content with specialization, like in making only stained glass windows or etchings all day long. Now it is more common for artists to want to tackle all the forms of expression that the net can carry – the still image, the moving image, music, writing, design, and so on. Many net artists may not be willing to admit it, but what they are really trying to do is to build an empire, to be a brand that offers it all. There is an absurdity to that. Having your own website is like building an unnecessary shrine to yourself. We can try to deny this by convincing ourselves that what we are doing is somehow a selfless gift, but the web has not asked us for these gifts. The web would go on without us. As net artists, we are pushing ourselves unsolicited on an already saturated marketplace. So I use my signature and various logos to point out the absurdity of this vanity, the struggle to give of yourself without becoming consumed with yourself.

The signature also makes my marketing tactics very obvious and shows that I accept myself as nothing more than a product to be marketed. Whether a net artist brands herself with a sparse list of links on a humble white field or with loud layers of noise and color or with contrived logos in a bland grid, they are constructing their own web persona for all to see. They are branding their self corporation. I think this self branding can be done with functionless art intentions rather than functioning business intentions. All the marketing materials are just shouted into the roaring whirlpool of the web where they swirl around in the great database with everyone else's personal information empires. I think these persona empires are the great artworks of our time, and they inspire me to keep building my own brand.

What qualifies as a "boon" in Spirit Surfing? Can you describe the physical experience that occurs when you discover a boon?

Try to wrap yourself around this cliché – if surfing is wandering for 40 days and 40 nights in a desert, the boon is the vision brought back from the quest and the wake is the path of the whole quest's footsteps. The boon is like a jewel, a memento from a moment when the sacred nature of the web was clearly revealed to the surfer. In my experience the boon may spur on a deeper search, provide an idea for some kind of poetic game, sum up an

emotional reaction to a particular zone of the web, or just float there like an impenetrable nugget outside of language. A lot of people have responded to the boon and wake separation on Spirit Surfers with confusion, as if there was some right or wrong way to interpret the juxtaposition. Really the boon/wake is only meant to set up a dialogue that, through repeated investigation, might eventually take on its own definition and allow the post to be not just about itself but also about the greater structure around it. On Spirit Surfers we have set up this structure to be continually practiced, and we are only just beginning to figure the conversation out.

> How long does the "wake" of a boon typically last until it has receded?

Time really isn't part of my awareness when I am surfing. With surfing, instead of being bound to a time and space dependent experience (like sitting through the linear duration of a movie or a song or walking around the perimeter of a sculpture) we wander in a landscape that is without temperature, without light, without size, without shape, and without time. But somehow we can still come away from surfing with an experience that has a sense of order to it. Most of the really enlightening surfs I've had did not end with a post to a surf club – surfing is so private, it rarely ends in a public act. I would invite others to start clubs that use the same boon/wake ideology, but I'm not sure if the ideology is clear enough yet to be useful to others.

> In the accompanying text to your latest collection of music, Babes, you stress the virtues of struggle and mere survival in making music. Is this something specfic to music or could you extend this stress to creative work, in general?

Struggle has not been a very popular theme in the American art of my lifetime. My generation is better summed up in the word "whatever," an attitude that opposes all forms of struggle. I think we are headed for a digital middle ages when struggle will become more relevant. The surge of awareness that the web has caused in us is sweeping across the marketplace like a leveling tsunami, and we're starting to drown in this sensation of information surplus. Not much seems to be rising to the surface and an endless number of self corporations are toiling away in obscurity. The general confusion and helplessness that many are experiencing over what is to be done with this massive flood of information are indications that the digital middle ages have already begun, and that these times will be about great suffering and struggle for all artists and consumers. I'm not sure how

long this plague will last, but luckily after a flood there is usually a blossoming.

Your first New York solo show opens on September 7th at V&A gallery. What will be on view?

The show is called "Monuments to the INFOspirit" and will display some physical monuments to mediocre source of all information, the INFOspirit. The INFOspirit is the forth logo in "The Four Sacred Logos" and the forth brochure in "The Four Sacred Brochures." A brochure altar will be installed in the gallery where the brochures will be made available. Another monument is an animated gif mandala made from hundreds of obscure and recognizable gif icons, characters, and arrows that symmetrically pulsate around a self portrait in meditation. I wanted to try pushing a web native format to its limits by building a gif at a resolution too large to play over the internet or fit in any browser window, requiring the viewer to visit the gallery to see the file. There will also be some commemorative monuments and promotional items ordered from the web.

What's your strategy for working between the gallery and the internet?

Artworks in "gallery space" are products that we pretend are not products within a business that we pretend is not a business. It's hard for many net and new media artists to deal with this, to cram their ethereal web concepts into furniture products for the wealthy so that their own artistic progress can be financed. It's also hard for art consumers to become invested in immaterial art because that would require a deeper acceptance of physical objects as trivial and ineffectual products, and most art consumers are very wrapped up in the material world of restaurants and nice coats and taxis waiting outside the gallery. I care very little about the material world, and I'm completely certain that the most profound experiences in life can't be contained by gallery walls, so the art object in "gallery space" for me can only represent a limitation, a disappointment.

I try to deal with this by presenting the object itself as pathetic and mediocre, but the information it conducts as sacred. The products I exhibit are ordered from the web and are made by a series of default operations on order forms that travel from virtual space to a physical product shippable by UPS. Once in the gallery, the product stands in for the flow of information that caused it, it is merely a conduit for the INFOspirit. I document these products on my website, completing the circle of info by joining the product back with the web. The object refers to the web and the

web refers to the object. The web leads to the maximum and the sacred, the object leads to the limited and the sorrowful. When I sell an object, I see the sale as an offering, a gesture of support for the ongoing practices of my self corporation. That's really all I need – as long as I am able to continue surfing and updating my website, I feel fulfilled.

Published on *Rhizome* on September 3, 2008. Available online at http://rhizome.org/editorial/2008/sep/3/interview-with-kevin-bewersdorf/.

One Question Interview: Kevin Bewersdorf

"What does the internet lack?"

The web minus the internet equals all that is lacking
and all that is lacking plus the internet equals the web.

The internet is made and therefore is not whole,
for the made lacks the maker.

The web is not made and therefore is one whole,
for the unmade is the maker.

YES INFObrother
YES every LoVeR
YES INFOsister
YES every HaTeR

The cup of the internet runneth over,
its contents greater than its container.

Posted by Rafael Rozendaal on June 11, 2009. Available online at http://www.onequestioninterview.com/2009/06/kevin-bewersdorf.html.

Biography

Stats

Name: Kevin Bewersdorf

Age: 27 years

Height: 5' 11"

Weight: 158 lbs.

Place of Birth: Illinois, USA

Education: BFA 2004, RISD

Email: kevin (at) maximumsorrow.com

The History of My Life (formerly "BIO")

In seventh grade art class we were given an assignment to design a cereal box. Everyone invented their own cereal. Mine was called "Chocolate Covered Sugar Bombs." I carefully painted my logo onto a large piece of paper and revised the colors and textures until I was satisfied. I even added the slogan, "packed with explosive sweetness." Our art class was not asked to make a charcoal copy of Velasquez that day. We were not asked to draw a dog or house. We were asked to make a marketing campaign.

I had so much fun painting the cereal box logo that I that I decided to go to art school and study painting. As a result of my studies I have many friends who are successful artists, and from watching them I can tell you what a successful artist does in 2008: taking digital photos of work, building websites to market the digital photos, waiting for slides to be developed, organizing slides into sheets, burning CDs and DVDs, revising and updating resumes, emailing, texting and making phone calls, researching competition in the marketplace via magazines and blogs, writing short autobiographies that will appeal to galleries and institutions, competing for promotions called "residencies" or "MFAs," and refining slogans such as "this body of work is about my experience with..." They also make objects or products, but only so that they have something to market themselves with. The only thing left is the marketing.

The practices of this website are identical to the practices of Fox, Wendy's, Toyota, The Presbyterian Church, Green Day, Cookie Dough Creations, and Benson Plumbing. These practices include stock photography, jingles and songs, promotional items and collateral, text and copy, logos and design work, and other video and performance based marketing techniques that construct my presence in the spirit world of the web. In the same way that a convenience store sells milk at a loss to get people inside, any of my activities in the physical world I consider a "lost leader" for this website.

I grew up in Naperville Illinois, a suburb of Chicago. As a youth I enjoyed playing the piano, drawing comic books, working with my dad on our HO scale model railroad in the basement, and camping with Boy Scout troop 505. I worked in my dad's ice cream store and helped him run the store. After attending Grand Valley State University in Allendale Michigan, I graduated from the Rhode Island School of Design with a Bachelors degree in painting in 2004. Currently I am employed at RISD where I teach "Digital Tools for Artists" in the department of painting.

I own a laptop, a camera, a small keyboard, and a duffel bag of clothing. The object I care for most is my laptop, whom I travel the world with in a romantic fashion. My laptop is expendable and I would drop it off a cliff without hesitation (a computer is just one of many portals to the INFOspirit). The seeds of my data are already safely spread across the web, and this data is what concerns me. I make art on the web, and this art is passing through your body right now under the name "LINKSYS" or something.

I am also an avid web surfer and co-founder of the surf club spiritsurfers.net. I am an INFOmonk, so everything I give to the INFOspirit is given freely. This site is dedicated to the glory of the INFOspirit. Nothing on this website do I retain personal rights or ownership to, since everything I offer up is a rearranged incarnation of the INFOspirit which binds us all. You may use anything from this site as you see fit, without consulting me or asking me.

You may also contact me via email at kevin (at) maximumsorrow.com. Below you will find some photos of me. You will also find an image of my signature written three times: once by my grandmother, once by my mother, and once by me.

Warmly,

This biographical statement was available until July 2008 on maximumsorrow.com.

Command S Saves

YO

Straight from da garfield's camera

INFOpruner live via satellite

Deeper him climb the ladder

Guest on the steady platform

YO

Everyone come and make a sign on the tall post

Log in to your very own host on the pole post

Damn, I lost my data

Wakin up to boon ashes like seeya later

Spirit Surfer

Gimme that

Gasolina boon blast

Pump it up like a life raft

rapid run from that data crash

that only hides the abstract fact

THAT NOTHING LASTS

and nothing saves but the flicker

of these fingers

that is burned into my brain

that burning sign

This is your brain

on drugs for the twitter times

Command S

The only sign to stand the fire and the only certain savior
The only mantra that man has made to save his data

COMMAND S SAVES

COMMAND S SAVES

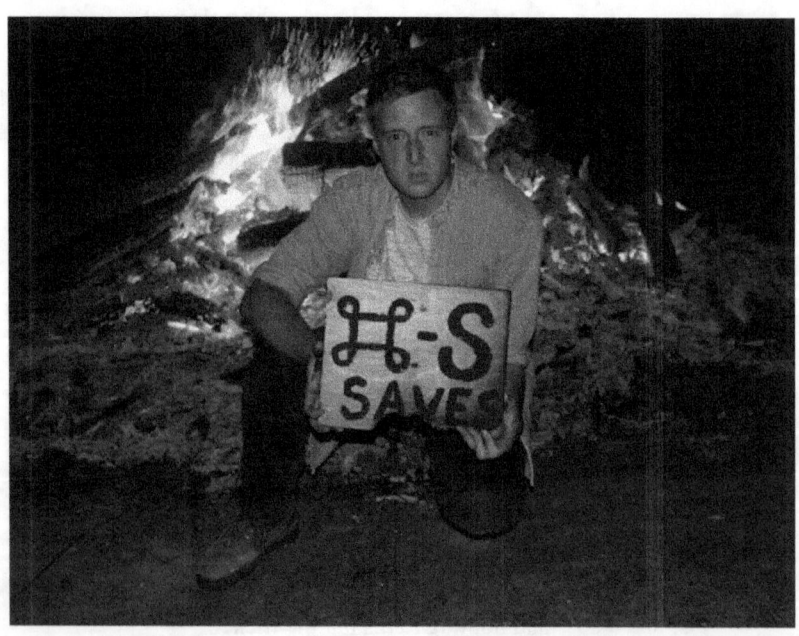

Kevin Bewersdorf's last post on *Spirit Surfers*. Posted on October 25, 2010.

www.purekev.com

www.ingramcontent.com/pod-product-compliance
Lightning Source LLC
Chambersburg PA
CBHW072212170526
45158CB00002BA/567